Contents

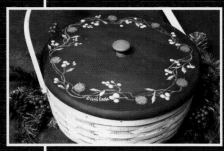

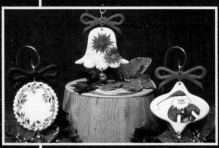
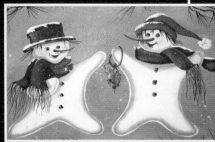
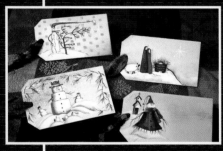
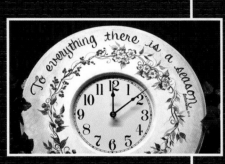
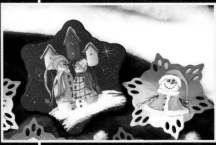
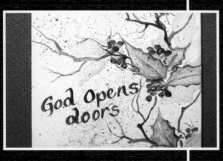
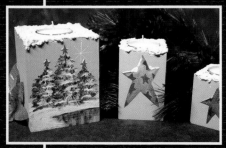
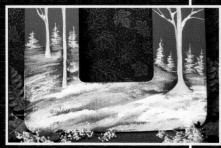

Bells & Berries Basket

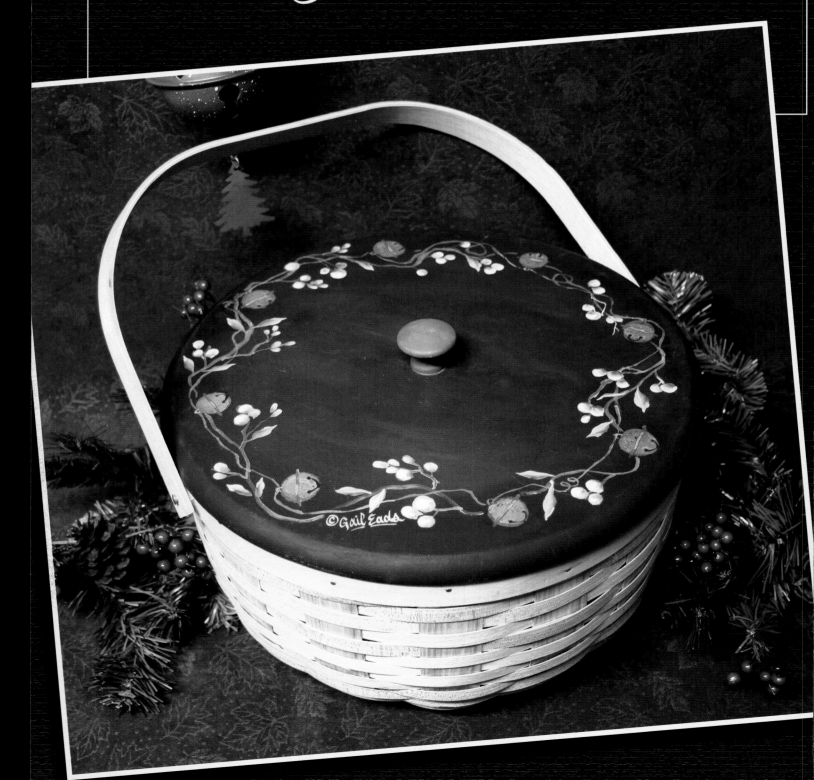

©Gail Eads

Bells & Berries Basket

Palette

Delta Ceramcoat Acrylic Paint

Burnt Sienna
Yellow
Black
Avocado
Lt. Buttermilk
Sonoma Wine

Surface

Wicker Basket with Wooden Lid
(#122-0085) available from Viking
Woodcrafts

Brushes

Loew-Cornell Series 3300 #8 Shader,
Series 4550 3/4" Wash, Jackie Shaw #1
Liner, Fan Brush (Spatter brush or old
toothbrush)

Supplies

100 Grit Sandpaper
White Transfer Paper
Delta Ceramcoat Matte Spray Varnish

Instructions

Basecoat the lid of the basket with
Black using the 3/4" Wash brush
adding a little Sonoma Wine to blend.
Let dry. Trace the pattern onto lid
using White Transfer Paper. Paint
the bells with Burnt Sienna using the
#8 Shader. Add Yellow to highlight
each bell. Spatter the ornament with
the Fan brush, Spatter brush or old
toothbrush using Black that has been
thinned to an ink-like consistency.
Using the #1 Liner, the line on the bell
is painted with Burnt Sienna and a
highlight of Yellow is put in the center
of the line. The holes in the bells are
painted Black by using the #1 Liner.
To create the wire effect, lines around
the basket rim are done by using the
#1 Liner with Burnt Sienna + Yellow.
Paint the vines using Lt. Buttermilk
+ Avocado. Paint the berries using
the #8 Shader with a double-load of
Lt Buttermilk + Avocado, keeping
the Lt. Buttermilk on the outside of
the berries. The knob on the lid is
basecoated with Avocado. Finish the
piece by spraying with Delta Matte
Spray Varnish.

©Gail Eads 2006

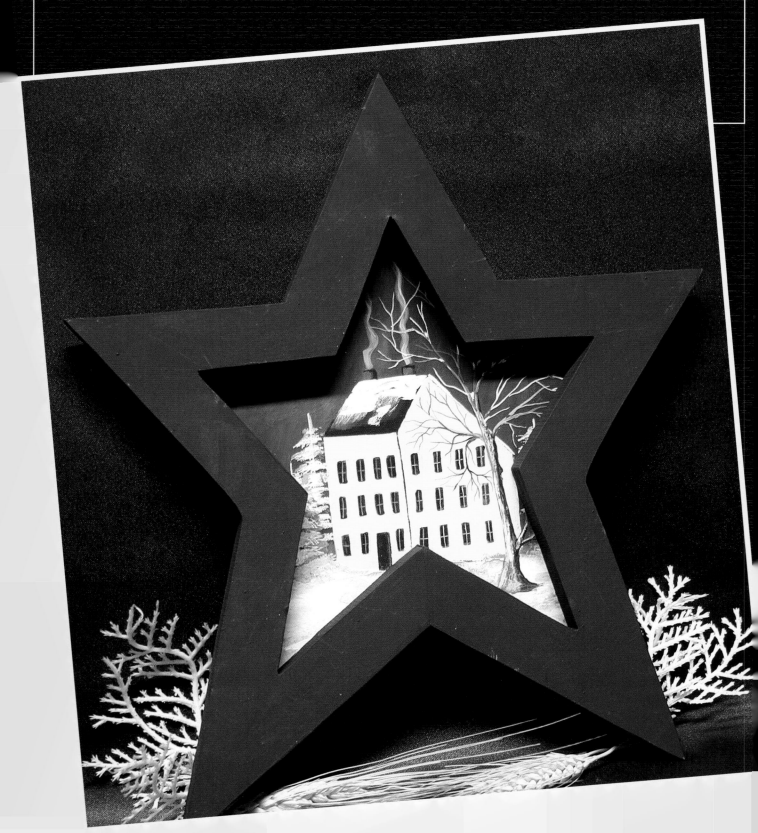

American Homestead

Palette

Delta Ceramcoat Acrylic Paint

Black Cherry
Pigskin
Dark Burnt Umber
Adriatic Blue
Antique White

Surface

Wooden Star Frame available from Gail Eads at The Country Life

Brushes

Loew-Cornell Series 3300 #8, #10 Shaders, Series 4550 3/4" Wash Brush, Jackie Shaw #1 Liner

Supplies

Delta Ceramcoat Matte Spray Varnish
White Transfer Paper
Delta Brown Antiquing Gel Stain
Delta Color Float

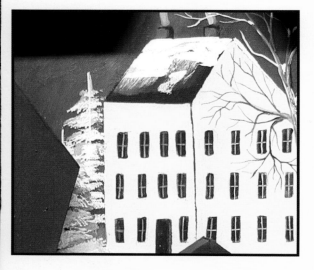

Instructions

Basecoat the frame and insert with Black Cherry using the 3/4" Wash brush, adding some Pigskin for color variation. Let dry. Transfer the pattern onto the insert with the transfer paper. Paint the house using a #10 Shader with Antique White. Paint the roof, windows, chimney and door with Dark Burnt Umber using a #8 Shader. Add crisscross lines to the windows with Pigskin using the # 1 Liner. The snow is White + Adriatic Blue, mixing the paint on the wood piece while painting it. The smoke is White + Adriatic Blue + a little water, using the #1 Liner brush. Double-load the #8 Shader and paint the pine trees in the background with White and Adriatic Blue, pouncing horizontally from tops to bottoms. Put linework on the trunk with White using the #1 Liner. Start the linework at the top of the trees. Add a few little lines of White for pine needles. Paint the tree in the foreground with Dark Burnt Umber. Highlight this tree using Pigskin and White. Use your liner for the finer branches at the top of the tree and using White add some snow in between some of the larger branches. Let dry. Sand the edges of the star. Use Delta Brown Antiquing Gel Stain if you wish to antique the frame. When antiquing, use a 1" brush and brush on the antiquing gel. Wipe off with a soft cloth. Let dry. Finish with Delta Matte Spray Varnish.

Holiday Ornaments

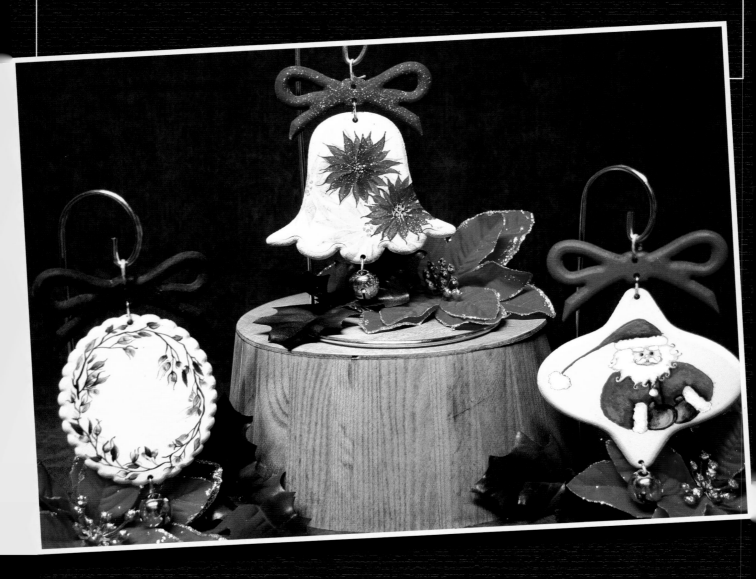

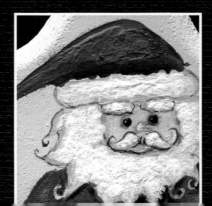

Poinsettia Bell Ornament

Palette

Delta Ceramcoat Acrylic Paint

Black Cherry
Celery Green
Dark Burnt Umber
Moroccan Red
Yellow
Antique White
Bright Red
Orange
Pine Green

Surface

MDF Bell Ornament with Gold Bell (#20-10794) available from Viking Woodcrafts

Brushes

Loew-Cornell Series 3300 #8 Shader, Series 4550 3/4" Wash, Jackie Shaw #1 Liner

Supplies

Delta Ceramcoat Matte Spray Varnish
Grey Transfer Paper

Instructions

Basecoat the ornament with Antique White. Let dry. Trace the pattern onto the bell ornament with the transfer paper. Paint the background leaves with Wedgewood Green + Sea Grass using the #8 Shader brush. Let dry. Paint the red poinsettias Moroccan with the #8 Shader. Shade the inner leaf with Moroccan Red + Dark Burnt Umber. Paint the dots on the centers of the flowers with Pine Green using the end of a paint brush or a stylus. Dot Yellow over the Green dots. Paint the bow Moroccan. Spatter with Antique White using an ink-like consistency of the paint + water. Spatter using a Fan brush, toothbrush or use a Spatter brush. Let dry and then spray with Delta Matte Varnish.

©Gail Eads 2006

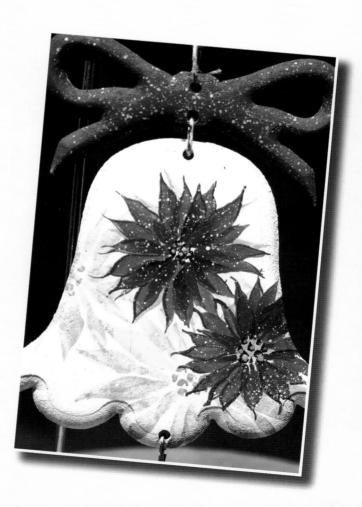

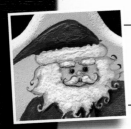

Santa Ornament

Palette

Antique White
White
Dark Burnt Umber
Bright Red
Orange

Surface

MDF Ornament with Gold Bell
(#20-10796) available from Viking
Woodcrafts

Brushes

Loew-Cornell Series 3300 #8 Shader,
Series 4550 3/4" Wash Brush, Jackie
Shaw #1 Liner

Supplies

Delta Color Float
Delta Ceramcoat Matte Spray Varnish
Grey Transfer Paper

Instructions

Basecoat the ornament with Antique
White using the 3/4" Wash brush.
Let dry. Trace the pattern onto the
ornament with transfer paper. Paint
the santa suit and hat with Bright
Red. Pounce over the coat and hat
with Orange while the Bright Red
is still wet. Paint the beard White +
Dark Burnt Umber mix. Pounce over
the beard, ball on the hat, button,
eyebrows and fur with the #8 Shader
using White. Paint the eyes and
mittens Dark Burnt Umber. Highlight
the mittens with Antique White.
Shadows on the hat, above the cuffs,
under the beard and in front of the
coat are floated with Dark Burnt
Umber + Color Float using the #8
Shader. Shade around the nose with
Bright Red + White. Dot the eyes
with White. Using the #1 Liner and
Dark Burnt Umber, outline the beard,
ball on the hat, around the cuffs
and mustache. Paint the bow Bright
Red. You may choose to spatter the
bow with Antique White or leave as
is. Finish with Delta Matte Spray.
Varnish.

©Gail Eads 2006

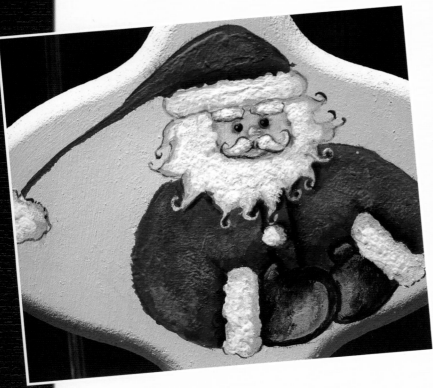

Roses & Buds Ornament

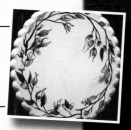

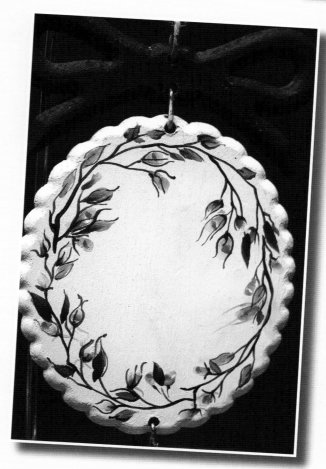

Palette

Delta Ceramcoat Acrylic Paint

Antique White
Black Cherry
White
Pine Green

Surface

MDF Oval Ornament with Gold Bell (#20-10795) available from Viking Woodcrafts

Brushes

Loew-Cornell Series 3300 #4 Shader, Series 4550 3/4" Wash Brush, Jackie Shaw #1 Liner

Supplies

Delta Ceramcoat Matte Spray Varnish
Grey Transfer Paper

Instructions:

Basecoat the ornament with Antique White using the 3 /4" Wash brush. Let dry. Trace the pattern onto the ornament with the transfer paper. With the #4 Shader, paint the roses using a double-load of Black Cherry and White. Also, make a few of the flower buds with the Black Cherry and the #1 Liner. Keep the brush with the White paint toward the outer edge.

The leaves are Pine Green using the #4 Shader brush. Some are lighter by adding water to the Pine Green. Line around the ornament using Dark Burnt Umber connecting the flowers and leaves. The bow is Pine Green. You may spatter the bow if you wish with Antique White.

©Gail Eads 2006

11

Snow Buddies

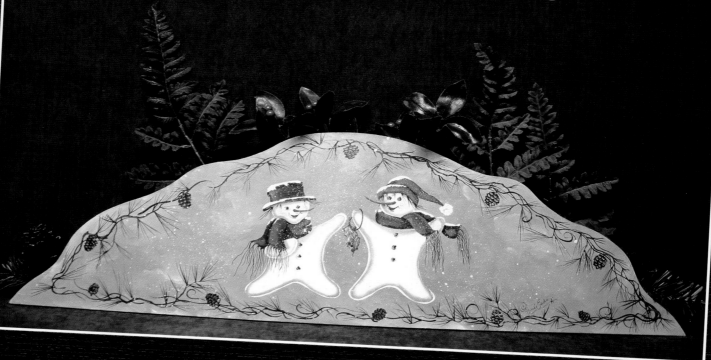

Snow Buddies Door Crown

Palette

Delta Ceramcoat Acrylic Paint

Palomino Tan	White
Dark Burnt Umber	Pine Green
Maroon	Yellow
True Red	

Surface

Door Crown (#134-0013) available from Viking Woodcrafts

Brushes

Loew-Cornell Series 3300 #8, #10 Shader, Series 4550 3/4" Wash Brush, Jackie Shaw #1 Liner

Supplies

Delta Ceramcoat Matte Spray Varnish
Grey Transfer Paper
Delta Color Float

Instructions

Use the 3/4" Wash brush to basecoat the Door Crown with Palomino Tan, swirling in White for a faux finish look. Let dry. Transfer the pattern onto the piece with transfer paper. Basecoat both of the snowmen with White. Use Palomino Tan to shade around the snowmen with the #8 Shader. Use Color Float to blend, keeping the paint on the outer edge of the snowman. Paint the eyes, buttons and line the mouth with Dark Burnt Umber. Paint inside the mouths with True Red. Paint hat on the first snowman Dark Burnt Umber using the #10 Shader. Highlight with Palomino Tan on the left side of the hat. Basecoat his scarf Maroon with the #10 Shader. Shade the scarf with Dark Burnt Umber and highlight with Yellow + Maroon. Basecoat the hat on the snow lady with Maroon. Shade the hat with Dark Burnt Umber. Highlight with Yellow + Maroon. Basecoat the scarf on the snow lady with Pine Green using the #8 Shader. Highlight the scarf with Yellow + Pine Green. The fringe on the snowman's scarf is linework using Dark Burnt Umber and Maroon. The fringe on the snow ladies scarf is Dark Burnt Umber + Pine Green. The holly is Pine Green with a highlight of White + Pine Green mix using the #8 Shader. The berries are Maroon with a highlight of True Red made by using the end of your paint brush. Dot berries with Dark Burnt Umber using the tip of the liner. The vines around the border are Pine Green linework. Add the twig branches around the border with Dark Burnt Umber. Basecoat the egg shaped circles for the pine cones Dark Burnt Umber. With Palomino Tan + Color Float, paint comma strokes inside the circles starting at tops of pine cones working down. Add pine needles to branches using Pine Green with the #1 Liner. Add more berries around the border. Spatter with White for the snow. Let dry. Finish with Delta Matte Spray Varnish.

©Gail Eads 2006

Gift Tags

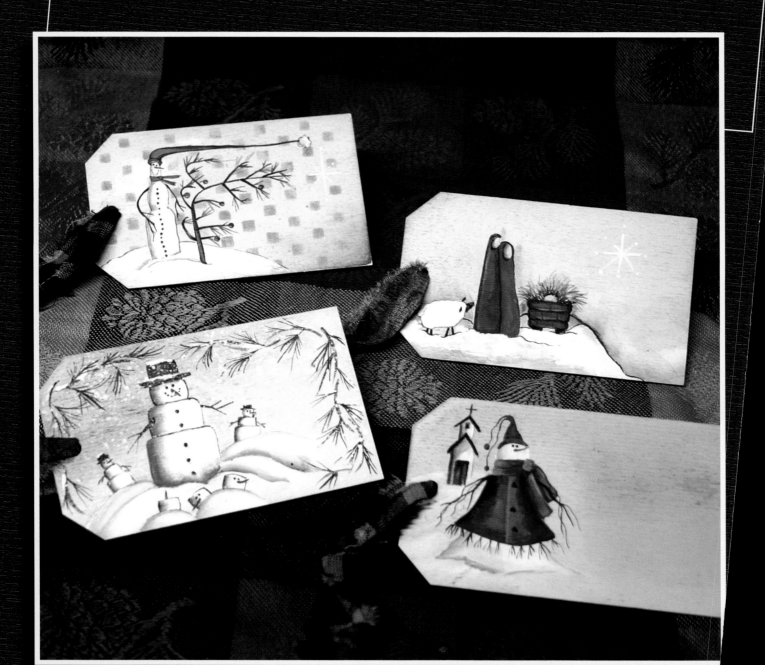

Windy Winter

Palette

Delta Ceramcoat Acrylic Paint

Black Cherry Burnt Sienna

Black Pine Green

Yellow

Surface

Wooden Gift Tag (207-0227) available from Viking Woodcrafts

Brushes

Loew-Cornell Series 3300 #8 Shader, Series 4550 3/4" Wash Brush, Jackie Shaw #1 Liner

Supplies

Delta Ceramcoat Matte Spray Varnish
Instant Tea (any grocery store)
Spray bottle (hardware store)
Homespun material approx. Torn Strip 10" x 2"
Checks Stencil (small checks) approx. 1/4" (Arts & Crafts store)
Delta Paint & Toss Sponges
Grey Transfer Paper

Instructions

Paint the wooden tag using Lt. Ivory and your 3/4" Wash brush. Let dry. Mix a small amount of water, ½ cup, with 2 tablespoons of Instant Tea. Shake this inside the spray bottle. Spray the tag with the tea mix. Allow to dry. With the Yellow and Burnt Sienna, use the stencil and apply the paint onto the wooden tag. Let dry.

Transfer the pattern onto the tag with the transfer paper.

Paint the snowman using the #8 Shader with Eggshell White + Burnt Sienna shading on the left side of the snowman. Paint the hat Black Cherry using the #1 Liner brush. Highlight the hat in the center with Yellow (while the Black Cherry is still wet). The eyes, buttons, arms and tree are Burnt Sienna + Black. The needles on the tree are painted Pine Green using the #1 Liner. The balls on the tree are Black Cherry, highlighted with a touch of Yellow. The ball on the end of the hat and the snow on the ground are Eggshell White. The nose is painted a mix of Black Cherry and Yellow. Outline the snowman and the tree with Black using the #1 Liner. Let dry. Apply the Delta Matte Spray Varnish to the tag. Let dry. Tie the torn fabric onto the tag.

©Gail Eads 2006

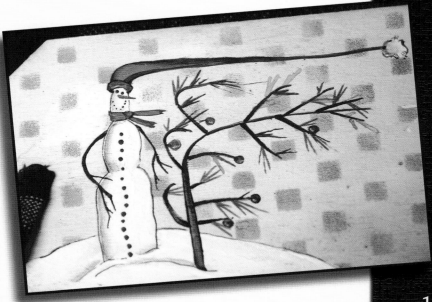

Christmas Blessings

Palette

Delta Ceramcoat Acrylic Paint

White Moroccan Red
Pigskin Dark Burnt Umber
Antique White Yellow
Pine Green Trail Tan

Surface

Wooden Gift Tag (#207-0227)
available from Viking Woodcrafts

Brushes

Loew-Cornell Series 3300 #8 Shader,
Series 4550 3/4" Wash, Jackie Shaw
#1 Liner

Supplies

Delta Ceramcoat Matte Spray Varnish
Instant Tea
Spray Bottle
Homespun Material approx. a 10" x 1"
Torn Strip
Grey Transfer Paper

Instructions

Paint the wooden tag using Lt. Ivory and the 3/4" Wash brush. Let dry. Mix a small amount of water (approximately a 1/2 cup) with 2 tablespoons Instant Tea. Shake this inside the spray bottle. Spray the tag with the tea mix. Allow the tag to dry. Using the transfer paper, trace the pattern onto the wooden tag. Paint the sheep White + Trail Tan using the #8 Shader. Paint Joseph's coat with Pine Green. Mary's coat is Moroccan Red with a highlight of Pigskin + Moroccan Red. The manger is painted Dark Burnt Umber using Pigskin to highlight. The sheep's mouth, ears and legs are Dark Burnt Umber. The faces of Mary, Joseph and Baby Jesus are Trail Tan + White, shading with Dark Burnt Umber. Highlight the faces using White. Paint the straw in the manger using Dark Burnt Umber, adding some Yellow highlights. The snow in the foreground is White. Shade around the snow using Dark Burnt Umber. Outline the sheep and foreground with the #1 Liner using the same color. The star in the sky is painted White using the #1 Liner. Apply the Delta Matte Spray Varnish to the tag. Let dry. Tie the fabric strip onto the tag.

©Gail Eads 2006

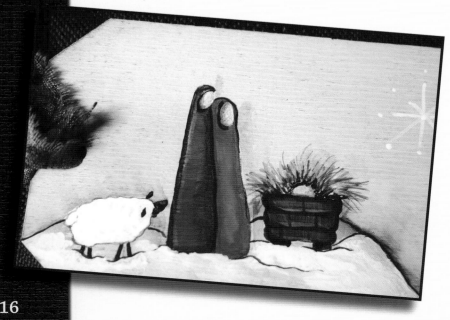

Marshmallow Snowmen

Palette

Delta Ceramcoat Acrylic Paint

Eggshell White
Burnt Sienna
Burnt Umber
Pine Green
Orange
Lt. Ivory

Surface

Wooden Gift Tag (#207-0227)
available from Viking Woodcrafts

Brushes

Loew-Cornell Series 3300 #8 Shader,
Series 4550 3/4" Wash Brush, Jackie
Shaw #1 Liner, Fan Brush

Supplies

Grey Transfer Paper
Delta Ceramcoat Matte Spray Varnish
Instant Tea from any grocery store
Spray bottle (hardware store)
Homespun Material approx. a 10" x 2"
torn strip

Instructions

Paint the wooden tag using Lt. Ivory.
Let dry. Mix a 1/2 cup of water with
2 tablespoons Instant Tea. Put the
mix into the spray bottle and shake.
Spray the tag with the tea mix. Allow
to dry. Transfer the pattern onto the
tag with transfer paper. Basecoat
the snowmen using a #8 Shader and
Eggshell White. Shade the left sides
of the snowmen using Burnt Sienna
+ water with the #8 Shader. The
eyes, mouth and buttons are painted
using the #1 Liner and Burnt Umber.
The noses are painted Burnt Sienna
with a highlight of Orange. The large
snowman has a Burnt Sienna hat. The
hats on the smaller snowmen in the
background are Pine Green. The arms
are linework of Burnt Umber as well
as the tree branches around the tag.
The pine needles are Pine Green using
the #1 Liner. The snow is painted with
a double-load of Eggshell and Burnt
Sienna, keeping the shading toward
the tops of each of the snow hills. The
snowmen are outlined with Burnt
Sienna. The snow is spattered with a
fan brush using Eggshell + water (ink
consistency). Add snow to the tops of
the hats using the liner. Finish with
Delta Matte Spray Varnish. Let dry.
Tie the rag strip to the tag.

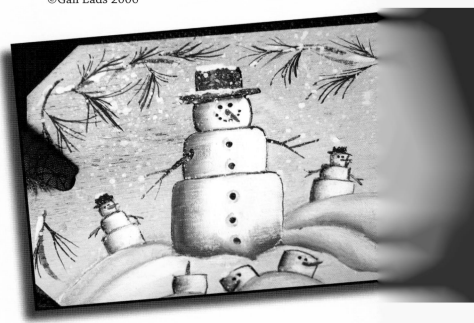

Winter in Red

Palette

Black Cherry
Black
Yellow

White
Dark Burnt Umber
Orange

Surface

Wooden Gift Tag (#207-0227)
available from Viking Woodcrafts

Brushes

Loew-Cornell Series 3300 #8 Shader,
Series 4550 3/4" Wash Brush, Jackie
Shaw #1 Liner

Supplies

Delta Ceramcoat Matte Spray Varnish
Instant Tea (any grocery store)
Spray bottle (hardware store)
Homespun material Torn Strip approx.
10" x 2"
Checks Stencil (small checks) approx.
1/4" checks (Arts & Crafts store)
Delta Paint & Toss Sponges
Grey Transfer Paper

Instructions

Basecoat the wooden tag with Lt. Ivory using the 3/4" Wash brush. Let dry. Mix a small amount of water, a ½ cup, with 2 tablespoons Instant tea. Shake this inside the spray bottle. Spray the tag with the tea mix. Allow to dry. Transfer the pattern onto the tag with transfer paper. With the #8 Shader, paint the church White. Shade the church with Dark Burnt Umber. Roof lines, cross on the church, and the door are Dark Burnt Umber using the #1 Liner. Highlight the door with White, (while the paint is wet). The snow on the ground is White. Paint the snowman White and shade with Dark Burnt Umber. Paint the snowman's coat, hat and scarf with Black Cherry. Shade the coat on both edges with Dark Burnt Umber. The buttons are 3 dots of Black. The arms are Dark Burnt Umber as well as the fringe on the coat. Highlight the hat and scarf with Yellow + Black Cherry. The nose is basecoated with Orange and shaded underneath with Dark Burnt Umber using the #1 Liner. Let dry. Use the Delta Matte Spray Varnish to finish. Let dry. Tie the torn fabric onto the tag.

©Gail Eads 2006

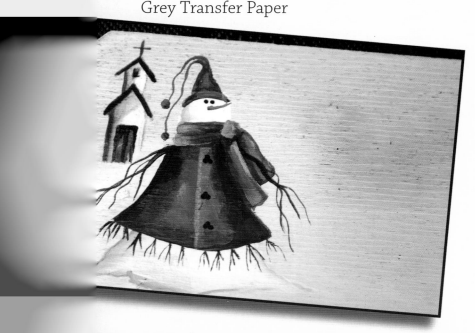

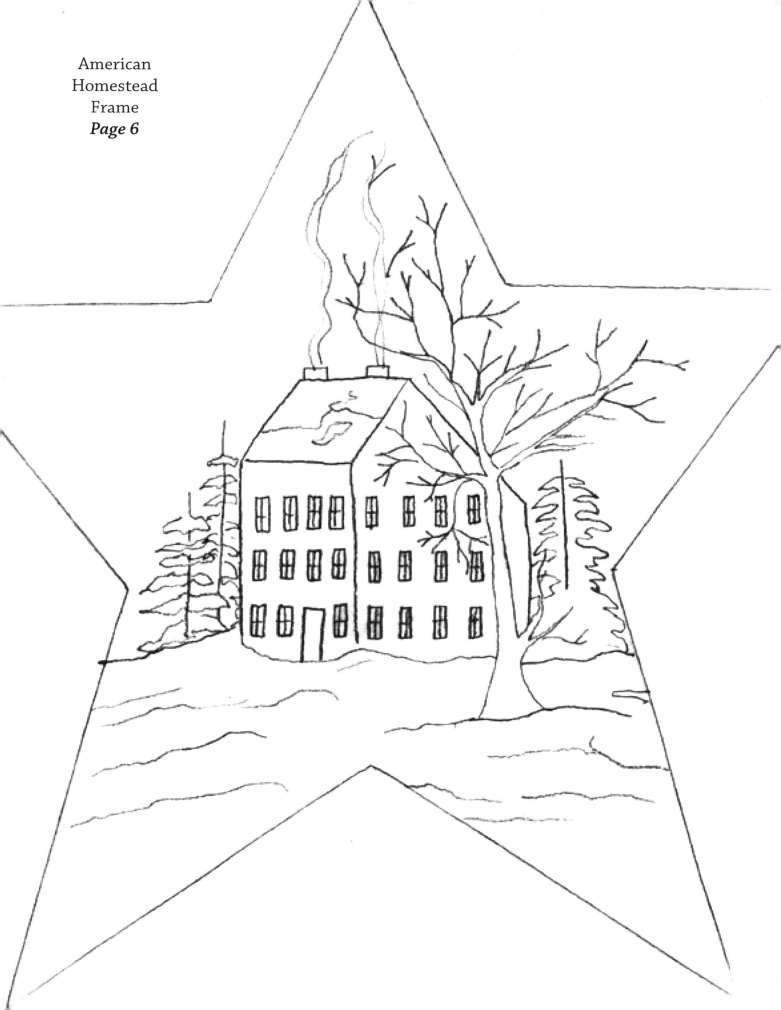

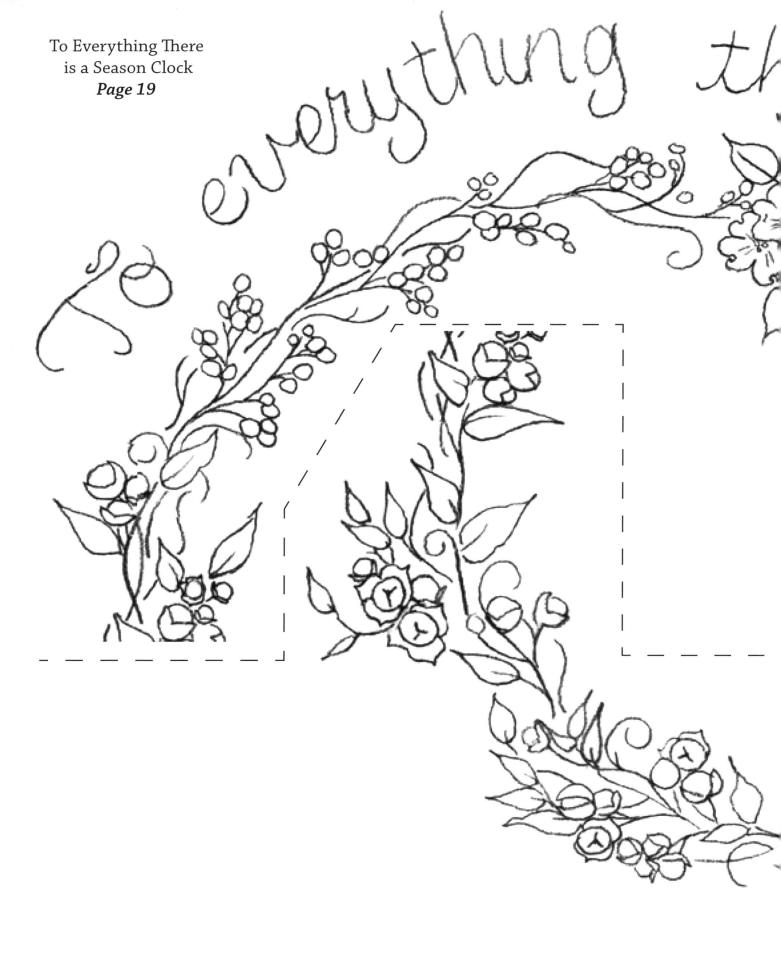

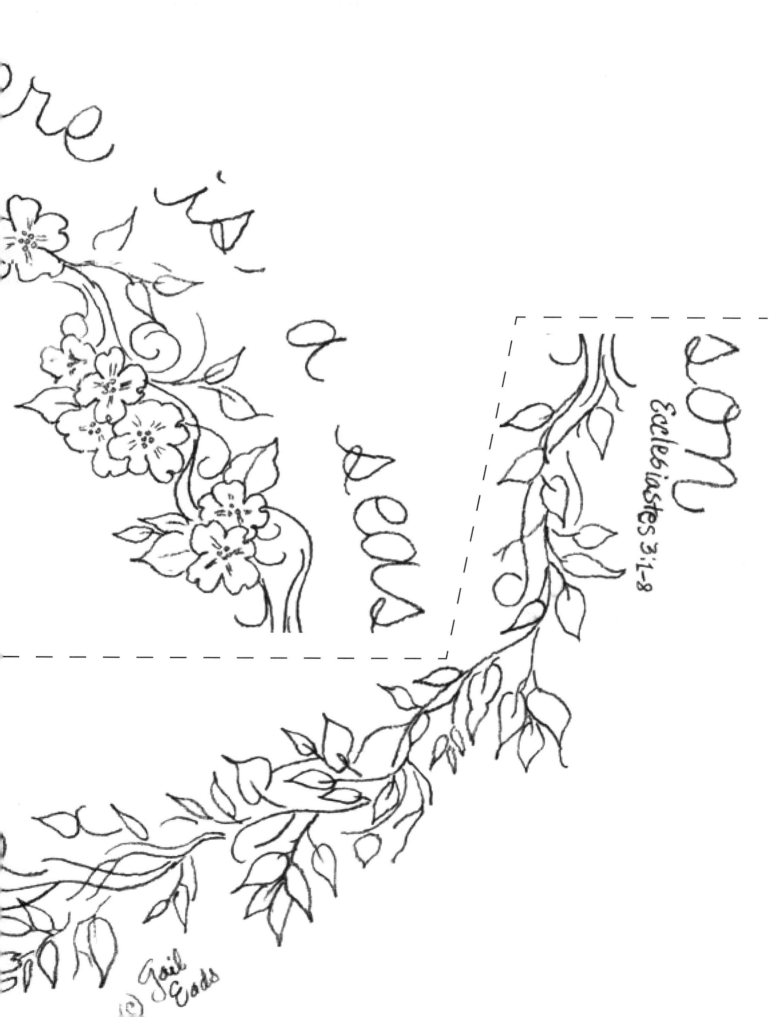

Ecclesiastes 3:1-8

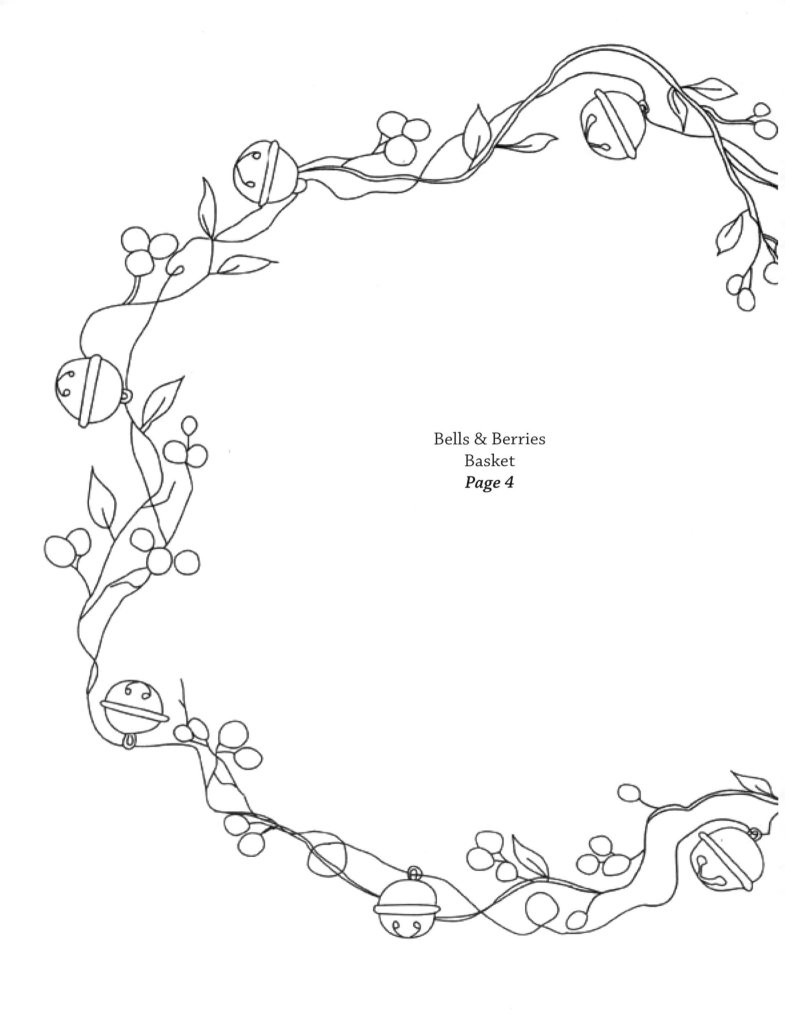

Bells & Berries
Basket
Page 4

Gift Tags
Page 14

Snowflake Friends
Coaster Set - Box
Page 22

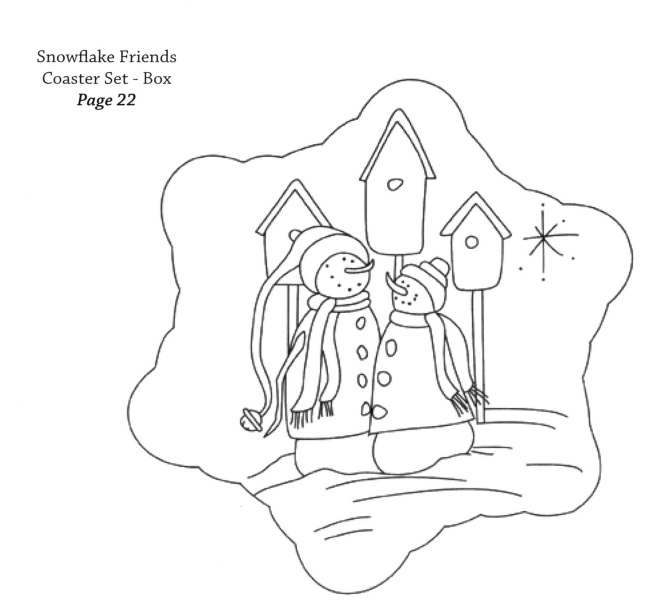

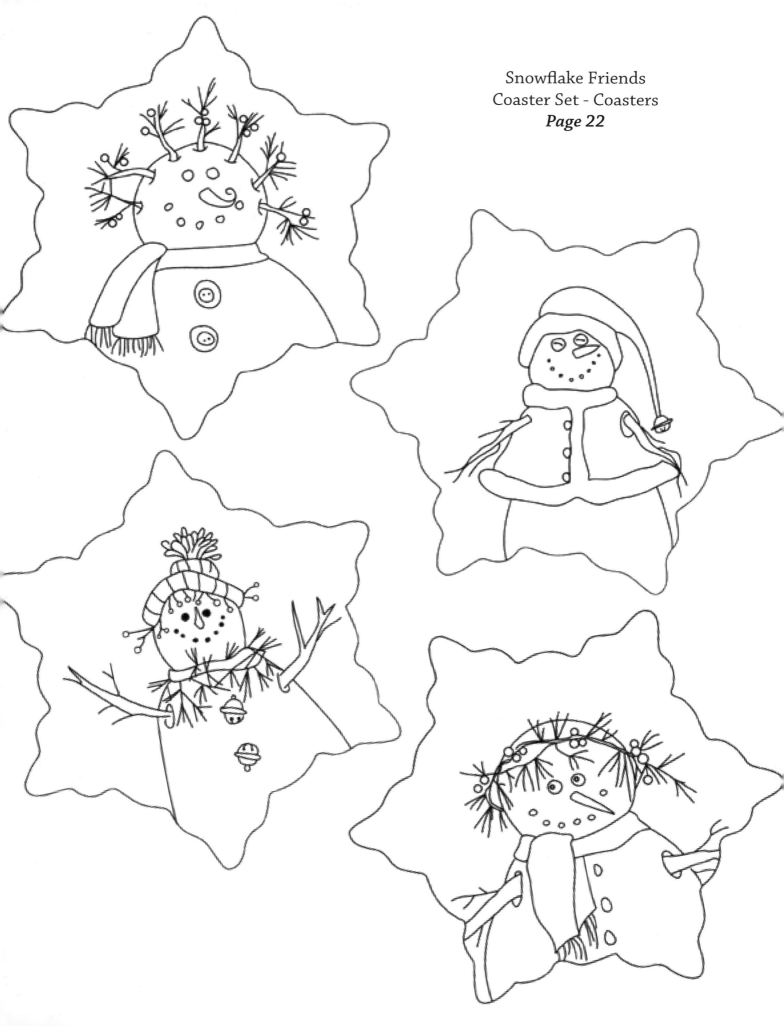

Snow Buddies
Door Crown
Page 12

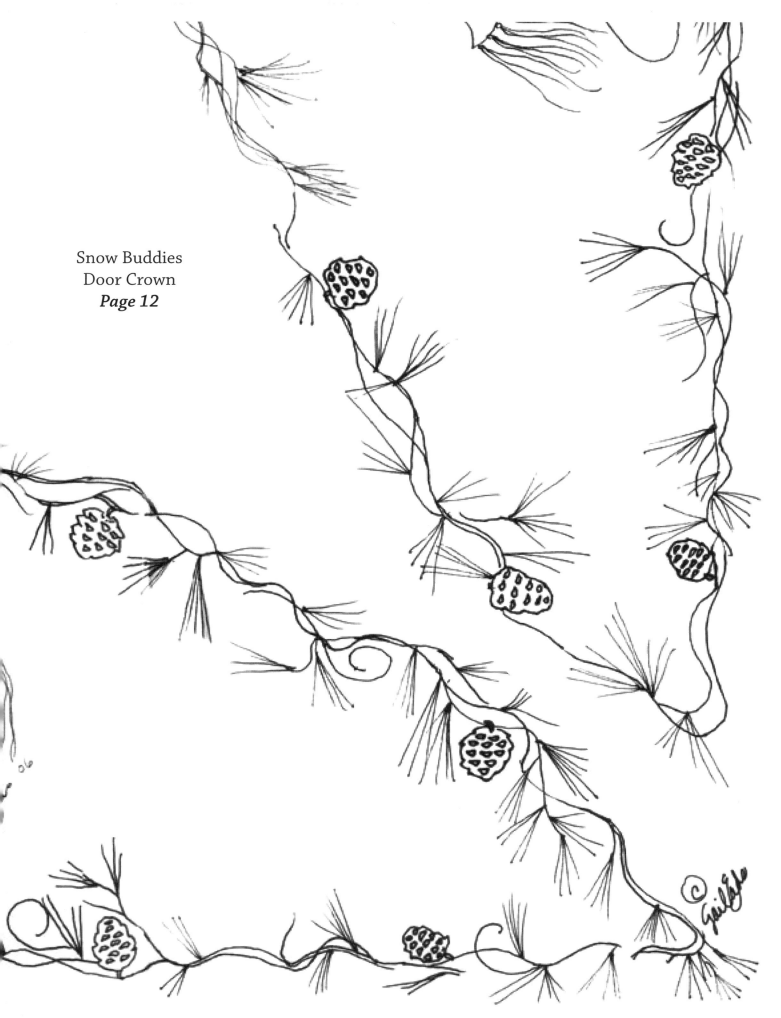

Snow Buddies
Door Crown
Page 12

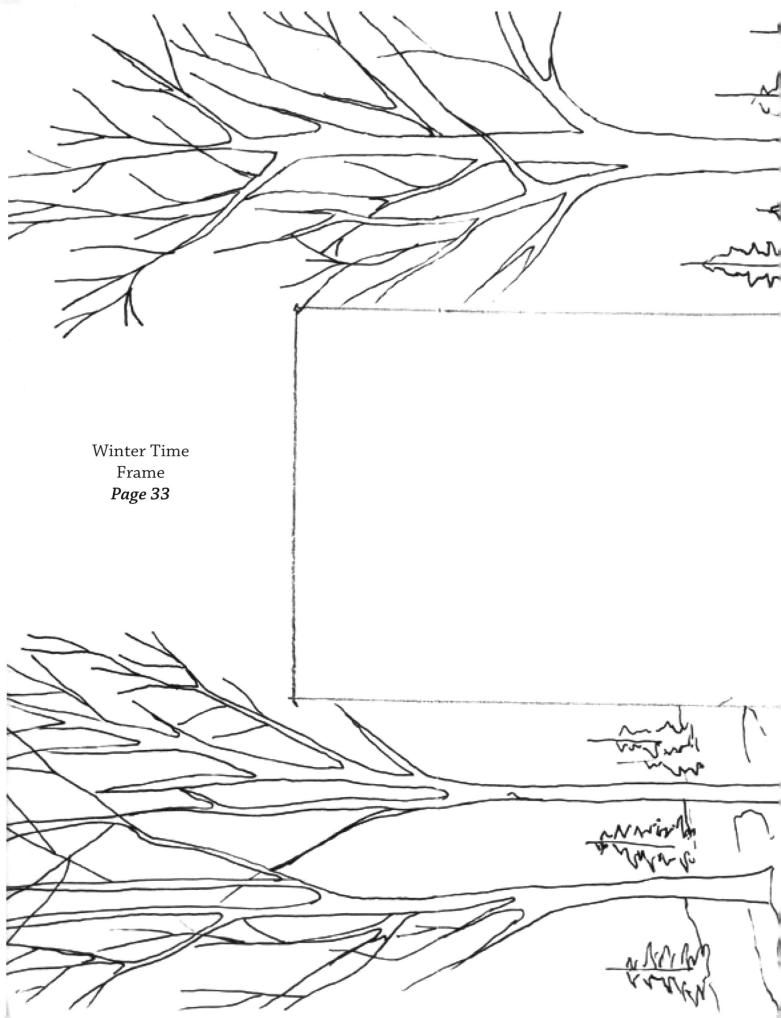

Winter Time
Frame
Page 33

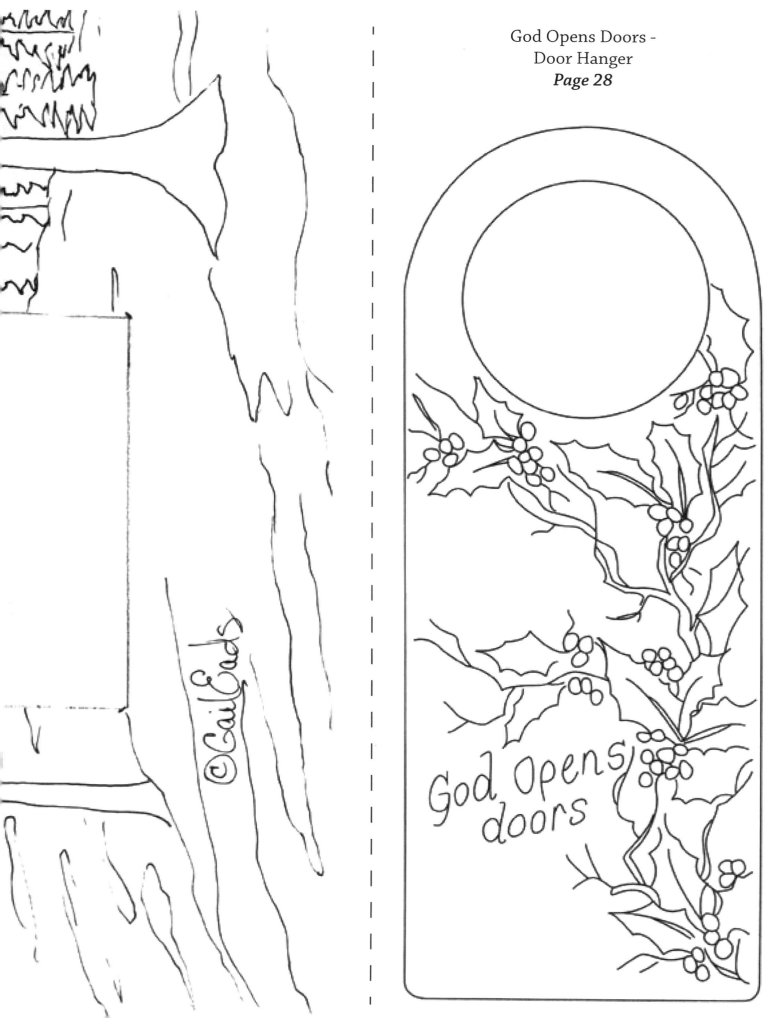

@GailEads

God Opens doors

O Christmas Tree
Candle Set
Page 30

Holiday Ornaments
Page 8

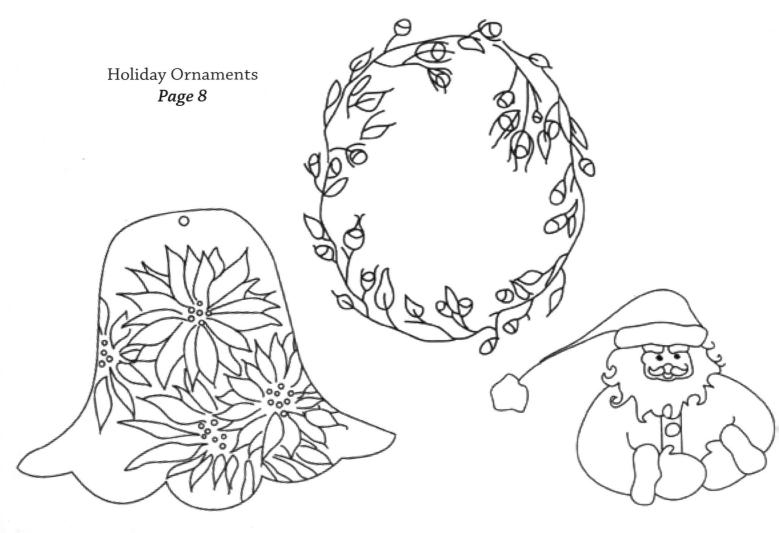

To Everything
There is a Season

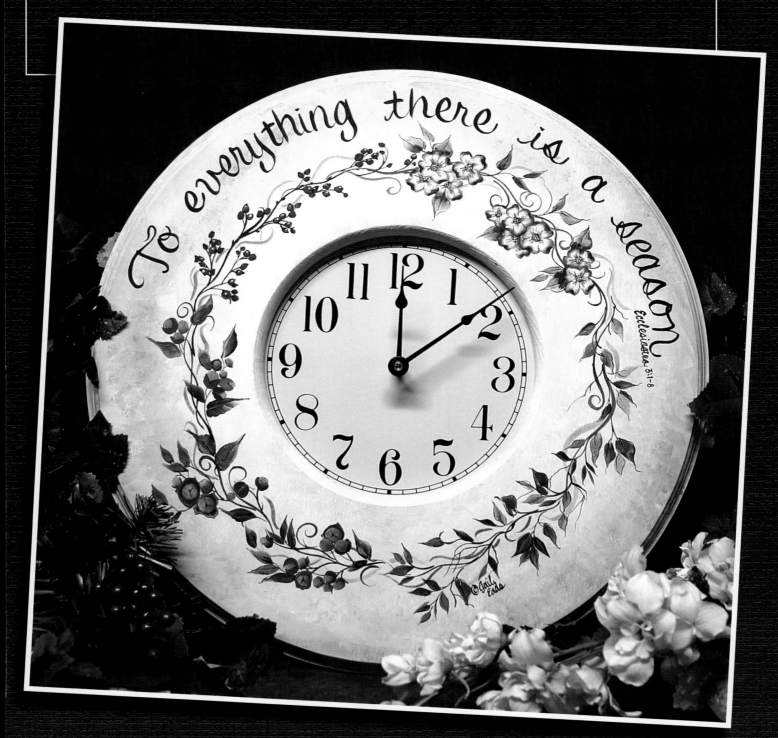

Palette

Delta Ceramcoat Acrylic Paint

Eggshell White Cloudberry Tan
Dark Burnt Umber Pine Green
Cinnamon Green Tea
Empire Gold Yellow
Moroccan Red

Surface

Clock (#137-9456) available from
Viking Woodcrafts

Brushes

Loew-Cornell Series 3300 #8, #10
Shaders, Series 4550 3/4" Wash Brush,
Jackie Shaw #1 Liner

Supplies

Delta Color Float
Delta Ceramcoat Matte Spray Varnish
Grey Transfer Paper

Instructions

Basecoat the clock Eggshell White
with the #3/4" Wash brush. Go over
the clock again with a double-load of
Eggshell White and Cloudberry Tan,
keeping the Cloudberry Tan towards
the outer edges using the #3/4" Wash
brush. Let dry. Transfer the pattern
onto the piece with the grey transfer
paper. Paint the vines using Pine
Green and Cloudberry Tan with the #1
Liner. Add Delta Color Float to lighten
some of the vines but keep some of
them solid.

Rosehip Berries: Paint the Berries
with Dark Burnt Umber, highlight
with Black Cherry on the corner of the
#8 Shader brush. Highlight again with
Black Cherry + Empire Gold. Dot some
of the berries with White using the
end of the paint brush. Dot the ends
of the berries with Dark Burnt Umber
with the tip of the #1 Liner brush.

Dogwood Blooms: Paint the blooms
using a double-load of White and
Black Cherry (on the outer edge) with
the #10 Shader. Shade the edge of
the leaves again with the #8 Shader
using Cinnamon + Dark Burnt Umber.
Highlight again on the inner leaves

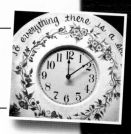

with White using the #8 Shader. Shade the center of the bloom with Cinnamon. Paint Pine Green dots in the center. Go over the center again with Green Tea dots. Paint the lines coming out from the center of the blooms with water + Dark Burnt Umber. Paint the leaves with the #10 Shader using Pine Green. Highlight some of the leaves using Green Tea. Outline the leaves with Dark Burnt Umber + water using the #1 Liner.

Summer Leaves: The summer leaves are painted Pine Green using the #10 Shader. Some of the leaves are a double-load of Pine Green and Cloudberry Tan. Paint some of the leaves using Green Tea. Line the leaves with the Dark Burnt Umber.

Bittersweet: Paint the berries using Orange and Moroccan Red using the #8 Shader. Highlight some of the berries with Yellow. Paint the petals of the berries using Moroccan Red and shade around the outer part of the berries with Cinnamon. The leaves are painted like those in the Summer Leaves instructions.

The words: "To Everything There Is A Season" Ecclesiastes 3:1-8 is painted with the #1 Liner using Dark Burnt Umber. Let dry. Finish the clock by spraying with Delta Matte Spray Varnish.

©Gail Eads 2006

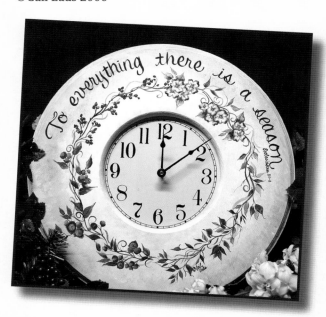

Snowflake Friends
Coaster Set

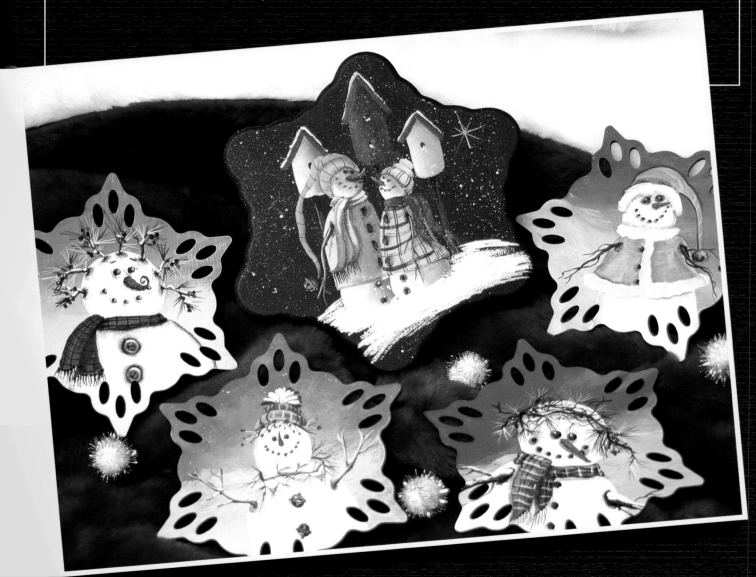

Coaster Box

Palette

Delta Ceramcoat Acrylic Paint

Black Cherry Yellow
White True Red
Nightfall Blue Celery Green
Pine Green Dark Burnt Umber
Black Pigskin
Orange Blue Velvet
Moroccan Red Antique White

Surface

Box with 4 Coasters (#207-0073), Individual Coasters (207-0117) available from Viking Woodcrafts

Brushes

Loew-Cornell Series 3300 #8 Shader, #10 Shader, Series 4550 3/4" Wash Brush, Series 7300C #8 Shader, Jackie Shaw #1 Liner

Supplies

Delta Ceramcoat Matte SprayVarnish
Snowflake Coaster (Viking Woodcrafts)
Grey Transfer Paper
White Transfer Paper

Instructions

Paint the box Black Cherry with 3/4" Wash brush. Let dry. Trace the pattern onto the box using the white transfer paper. Paint the first birdhouse with a double-load of Nightfall Blue + White using the #8 Shader. The second birdhouse is basecoated with Black Cherry + True Red (double-load) and the third birdhouse is a double-load of Celery Green + White. The roofs and posts of each house is Dark Burnt Umber using the #1 Liner. Highlight the roofs with Pigskin. Dot the holes of the houses with Dark Burnt Umber. Paint the snowmen with a double-load of White + Nightfall Blue using the #8 Shader. Paint the coat of the first snowman with Yellow, highlighting the left side of his coat with White. Paint the second snowman coat and hat with a Yellow and White blend. Paint the stripes on the coat and hat with Pine Green. The buttons are Dark Burnt Umber on both the snowmen. The arms, eyes, mouths and buttons are Dark Burnt Umber using the #1 Liner brush. Highlight the second snowman's buttons with Black Cherry + Yellow. The first snowman's scarf is Adriatic Blue, highlighted with White using the #8 Shader. The other scarf is painted Black Cherry with a highlight of True Red. The noses are Orange. The snow in the foreground is White. Paint the snow on top of the birdhouse roofs, in the holes, with White. The bell on the hat is Dark Burnt Umber with a highlight of Pigskin. The cheeks of the snowmen may be dry-brushed with True Red. Shade around the buttons, arms, and hats with a wash of Dark Burnt Umber. Spatter snow over the lid with a fan brush or old toothbrush. To finish, spray with Delta Matte Spray Varnish.

©Gail Eads 2006

Snowflake Friends Coaster

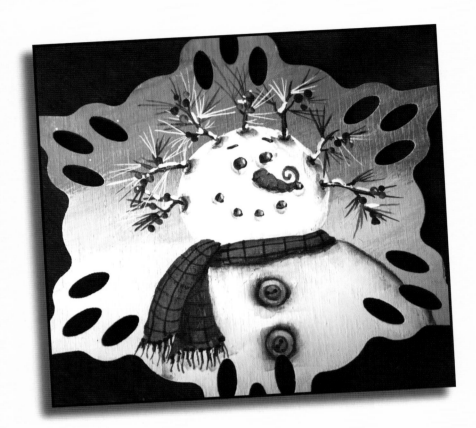

See list of palette and supplies on page 23.

Belle Snowflake

Basecoat the snowflake with Blue Velvet and blend in White towards the bottom with the 3/4" Wash brush. Let dry. Paint the snowman White with the #10 Shader brush. Let dry. Transfer the pattern onto the snowflake with grey transfer paper. Paint the eyes, twigs on top of the head, and mouth using Dark Burnt Umber. Highlight the twigs, eyes and mouth with Pigskin. Add pine needles to the twigs with Pine Green and White. The berries are painted with the Black Cherry and some are highlighted with True Red. The nose is painted Orange. Paint the scarf, using the #10 Shader, with Black Cherry. Highlight the scarf with Orange. Add Dark Burnt Umber lines onto the scarf. The buttons are Orange and highlighted with White on the tops. Shade around the buttons, eyes, twigs on the head, nose, and scarf with Dark Burnt Umber + Water. Add dots to the buttons with Dark Burnt Umber. The fringe on the scarf is Black Cherry. Finish the coaster with Delta Matte Spray Varnish.

©Gail Eads 2006

24

Snowflake Friends Coaster

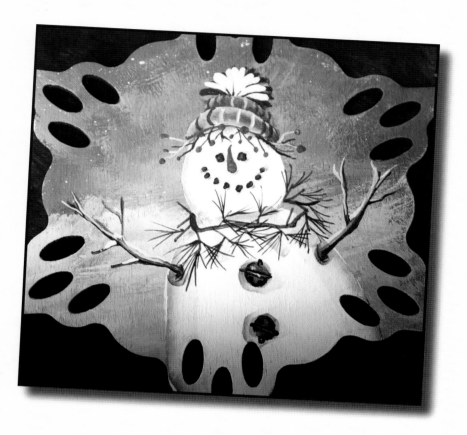

See list of palette and supplies on page 23.

Ollie Snowflake

Basecoat the snowflake with Blue Velvet and blend in White towards bottom with the 3/4" Wash brush. Let dry. Basecoat the snowman White with the #10 Shader. Let dry. Transfer the pattern onto the snowflake with the grey transfer paper. Paint the eyes, mouth, bells, arms, twigs and branch around the neck with the #1 Liner, using the Dark Burnt Umber. Paint the hat and pine needles Pine Green using the #8 Shader. Highlight the hat with Yellow + White using the #8 Shader. The lines on the hat are White and Pine Green. Dot the berries under the hat with Moroccan Red and Orange. Highlight the bells with the Pigskin. The line in the center of the bell is Dark Burnt Umber with a highlight of White. The dots on the bells are Black. The top (ball) of the hat is painted with Pine Green. Go over the Pine Green with White + Pine Green, then again with the White. The nose is painted Orange. Shade the eyes, under the hat, arms, bells, mouth and nose with a wash of Dark Burnt Umber using the #8 Shader. Highlight the arms with Antique White. Finish the snowflake with Delta Matte Spray Varnish.

©Gail Eads 2006

Snowflake Friends Coaster

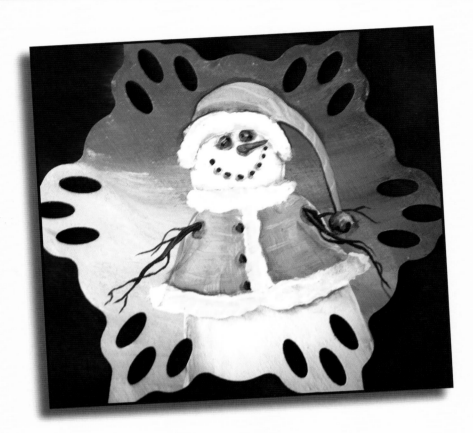

See list of palette and supplies on page 23.

Sam Snowflake

Basecoat the snowflake with Blue Velvet and blend in White towards the bottom with the 3/4" Wash brush. Let dry. Transfer the pattern onto the snowflake with transfer paper. Paint the snowman White with the #10 Shader brush. Let dry. Paint the snowman's coat and hat with Pigskin and the #10 Shader brush. Put highlights in with Yellow. The mouth, buttons and arms are Dark Burnt Umber using the #1 Liner. Highlight the arms with Pigskin. Paint fur on the coat and hat with White. The eyes are highlighted with Orange. Basecoat the nose Orange. Paint the dots on the eyes and the thread with Dark Burnt Umber. Highlight the thread with Yellow. Using a wash of the Dark Burnt Umber, shade around the fur, eyes, mouth, and arms. Let dry. Finish the piece with Delta Matte Spray Varnish.

©Gail Eads 2006

Snowflake Friends Coaster

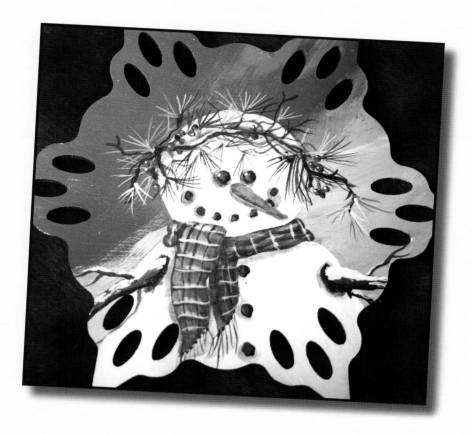

See list of palette and supplies on page 23.

Twiggy Snowflake

Basecoat the snowflake with Blue Velvet and blend in White towards the bottom with the 3/4" Wash brush. Let dry. Paint the snowman White with the #10 Shader. Let dry. Transfer the pattern onto the snowflake with grey transfer paper. Paint the twigs on the head of the snowman using Dark Burnt Umber + Pigskin. Add Pine Green and White for the needles using the #1 Liner brush. The berries are basecoated Black Cherry and then dotted and highlighted with True Red. Add a tiny dot of White to some of the berries with the tip of the liner brush.

The scarf is Pine Green with a highlight of White using the #10 Shader. Paint Pine Green lines and White lines on the scarf with the #1 Liner. The eyes, mouth, buttons and arms are Dark Burnt Umber. The nose is Orange with a shadow of Black Cherry underneath. Shade around the eyes, nose, buttons and arms with the #10 Shader using Dark Burnt Umber thinned with water. Add White to arms for snow. The tiny dots on the eyes are applied with White. Let dry and finish with Delta Matte Spray Varnish.

©Gail Eads 2006

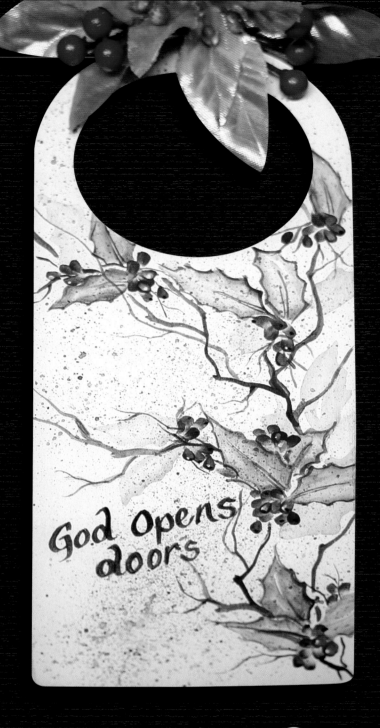

God Opens Doors
Door Hanger

Door Hanger

Palette

Delta Ceramcoat Acrylic Paint

Eggshell White
Avocado
Sonoma Wine
Sweetheart Blush
Yellow
Black

Surface

Door Hanger (#207-0197) available from Viking Woodcrafts

Brushes

Loew-Cornell Series 3300 #8 Shader, Series 4550 3/4" Wash Brush, Jackie Shaw #1 Liner, Fan Brush

Supplies

Delta Ceramcoat Matte Spray Varnish
Grey Transfer Paper

Instructions

Basecoat the door hanger Eggshell White with the 3/4" Wash brush. Let dry. Transfer the pattern onto the piece with transfer paper. With water using the corner of brush loaded with Avocado, paint the holly using the #8 Shader. Keep the paint on the outer edges of the holly. Paint more holly in the background with water + Avocado making a light washed look using the #8 Shader. The berries are Sonoma Wine, and some of them are Sweetheart Blush. The twigs are linework using the #1 Liner with Sonoma Wine + Black + Yellow. Dot some of the berries with Eggshell White. The lettering is Avocado + Black. Spatter the piece with Avocado + Sweetheart Blush. Let dry. Finish with Delta Matte Spray Varnish.

©Gail Eads 2006

O Chirstmas Tree
Candle set

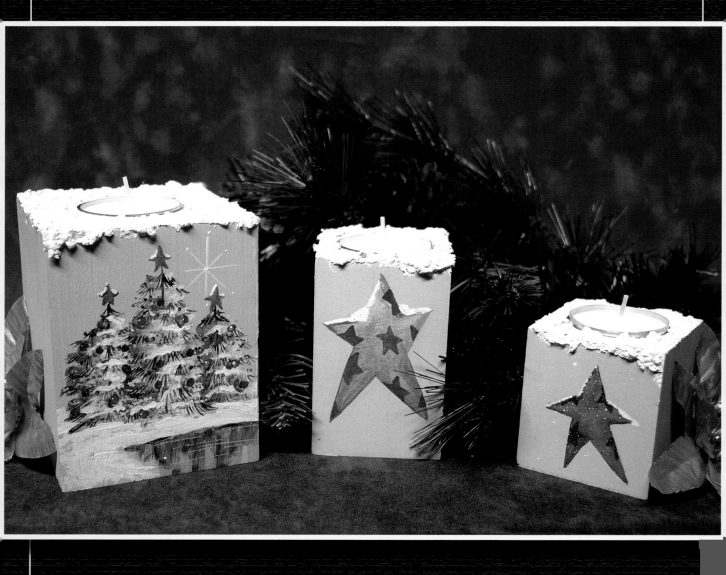

O Christmas Tree Candle Set

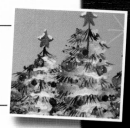

Palette

Delta Ceramcoat Acrylic Paint

Moss Green
Avocado
Poppy Orange
Burnt Sienna
Sonoma Wine

Pine Green
Light Buttermilk
Sweetheart Blush
Yellow

Surface

Wooden Candle Block-Set of 3
(#200-0732) available from Viking
Woodcrafts

Brushes

Old scruffy brush (I use an old #10
Shader)
Loew-Cornell Series 3300 #10 Shader,
Series 4550 3/4" Wash Brush, Jackie
Shaw #1 Liner
Fan Brush, Old Toothbrush or
Speckling Brush

Supplies

Tub O' Texture Snow
Delta Ceramcoat Matte Spray Varnish

Instructions

Basecoat the 3 wooden candle blocks
with Moss Green using the 3/4" Wash
brush. Let dry.

Large Candle Block: With the
scruffy brush, double-load Avocado
on the left side of the brush and
Light Buttermilk on the other side,
apply horizontal strokes starting

at top of the tree on the left and work
your way down to the ground. Paint
the two smaller trees using the same
colors and the scruffy brush. With
the #1 Liner, add more snow using
Light Buttermilk. Add Pine Green and
Avocado using mini brush strokes
to create more pine needles. The
ornaments on the trees are painted
with the tip of the #10 Shader using
Sweetheart Blush and Poppy Orange.
Highlight some of the ornaments with
a dot of Light Buttermilk. Add Light
Buttermilk in front and on the sides of
the trees and to the left of the water.
Paint Pine Green + Avocado across the
edge of the water closest to the trees

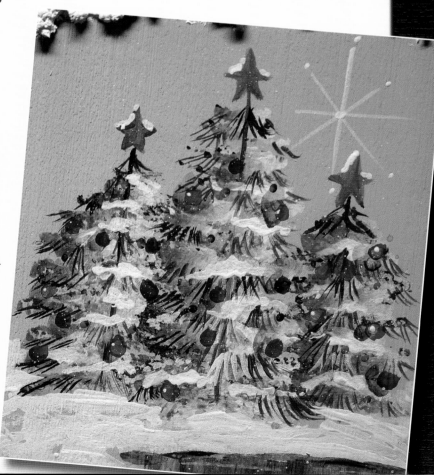

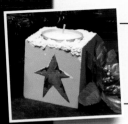
using the #1 Liner. With the shader, pull down vertically while the paint is still wet to create shadows. Paint Poppy Orange & Sweetheart Blush dots in the water. Pull down once again with the shader. Paint lines horizontally across the water with Light Buttermilk. Stars on Trees: Paint stars with liner brush using Burnt Sienna. Highlight the star with Yellow. Add Light Buttermilk to tops of the stars. Paint four lines crisscrossed for the star in the sky.

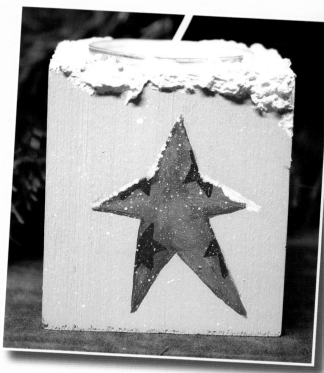

Small Candle Block: Paint the star using Burnt Sienna + Yellow. Blend. The smaller stars, inside of the large star, is painted using Sonoma Wine. Add Light Buttermilk on top of the star for the snow effect.

* The tops of each block has Texture Snow applied to it using the end of an old brush or toothbrush. Each block is spattered with snow using a fan brush or old toothbrush. Let dry. I would wait at least 4 hours for snow to dry before applying Delta Matte Spray Varnish.

Gail Eads 2006

Medium Candle Block: Paint the star using Burnt Sienna + Yellow and blend. Add Light Buttermilk to highlight. Paint the smaller stars inside the larger star using Burnt Sienna. Add Light Buttermilk on top of the star for a snow effect.

Winter Time

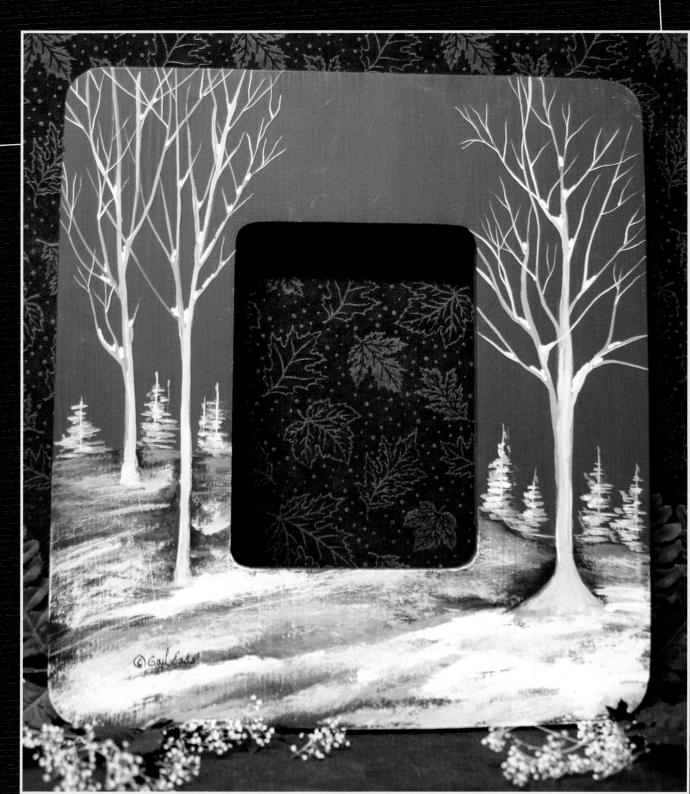

Winter Time Frame

Palette
Maroon
Palomino Tan
White
Dark Burnt Umber

Surface
Wooden Frame (#24-3588) available from Viking Woodcrafts

Brushes
Loew Cornell Series 3300 #8 Shader, Series 4550 3/4" Wash Brush, Jackie Shaw #1 Liner, Fan Brush

Supplies
Delta Ceramcoat Matte Spray Varnish
White Transfer Paper
Delta Color Float

Instructions
Basecoat the Frame with Maroon using the 3/4" Wash brush. Paint the sides and around the inside also. Let dry. Transfer the pattern onto the piece with the white transfer paper. With the #8 Shader, paint the trees Palomino Tan. Paint the smaller branches with the #1 Liner using Palomino Tan. Paint some of the branches with White. Add White to highlight the trees. Add White for the snow inbetween the branches. Paint the background Dark Burnt Umber + Palomino Tan. Dry-brush with the side of the 3/4" Wash brush horizontally using Palomino Tan over the Dark Burnt Umber + Palomino Tan. Highlight with White (dry-brush) horizontally. Spatter the snow with a Fan brush. Finish the frame with Delta Matte Spray Varnish.

©Gail Eads 2006